W9-CAF-246

The Things A String Can Be

Written by Julie Goulis

Illustrated by John Ferguson

Bubblegum Books, LLC
Cleveland, Ohio

BUBBLEGUM BOOKS™

Published by:
Bubblegum Books, LLC
P.O. Box 94106
Cleveland, OH 44101-6106

Managing Editor: Brad Hauber

Visit our website at www.bubblegumbooks.com

ISBN 0-9754621-0-5

Library of Congress Control Number: 2004106347

Printed in Hong Kong

First Printing 2004

Attention teachers, groups and other organizations: Quantity discounts are available on bulk purchases of this book for educational purposes, gift purposes, fundraisers or as a premium item. For information, please e-mail: info@bubblegumbooks.com

This book is dedicated to good old-fashioned imagination.

The sun peeked out from the big, fluffy clouds.

Finally! Thought Sam. I can go out and play.

You see, it had rained for days and days.

Big, wet, cold raindrops falling from the sky,

Leaving nothing to do but play inside.

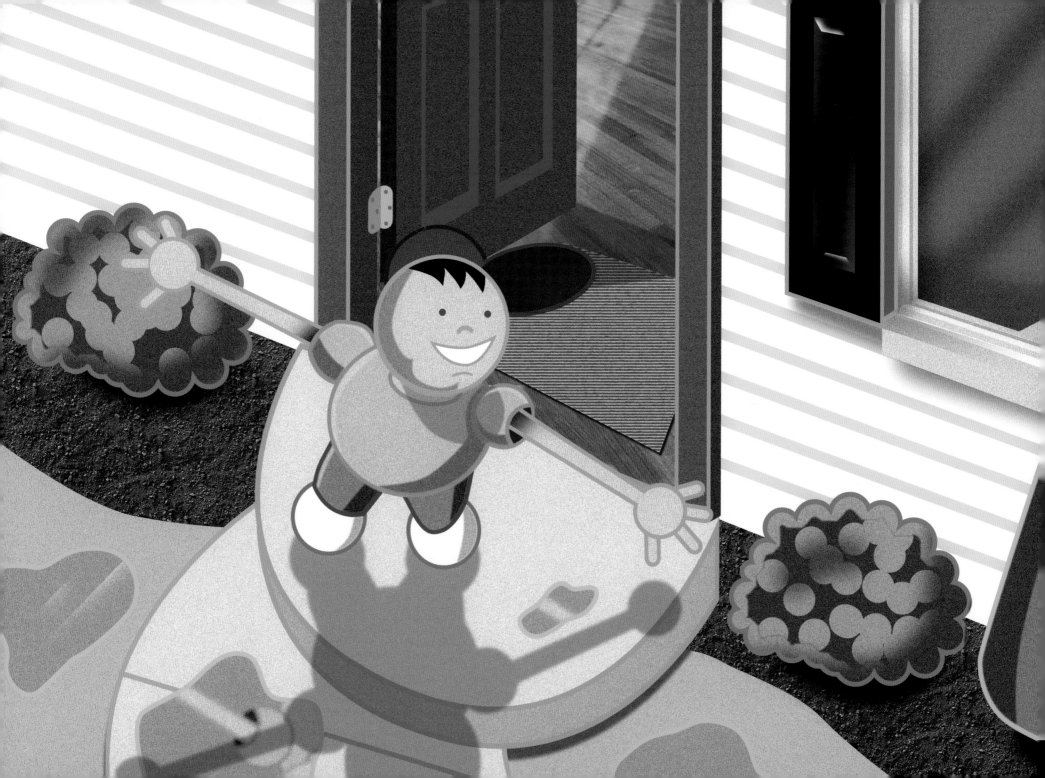

"Mommy! Mommy! Where are my toys?
I'm going outside with the other girls and boys."

"They're all put away for the day, but that's okay.
Just see what you can find, what the rain left behind."

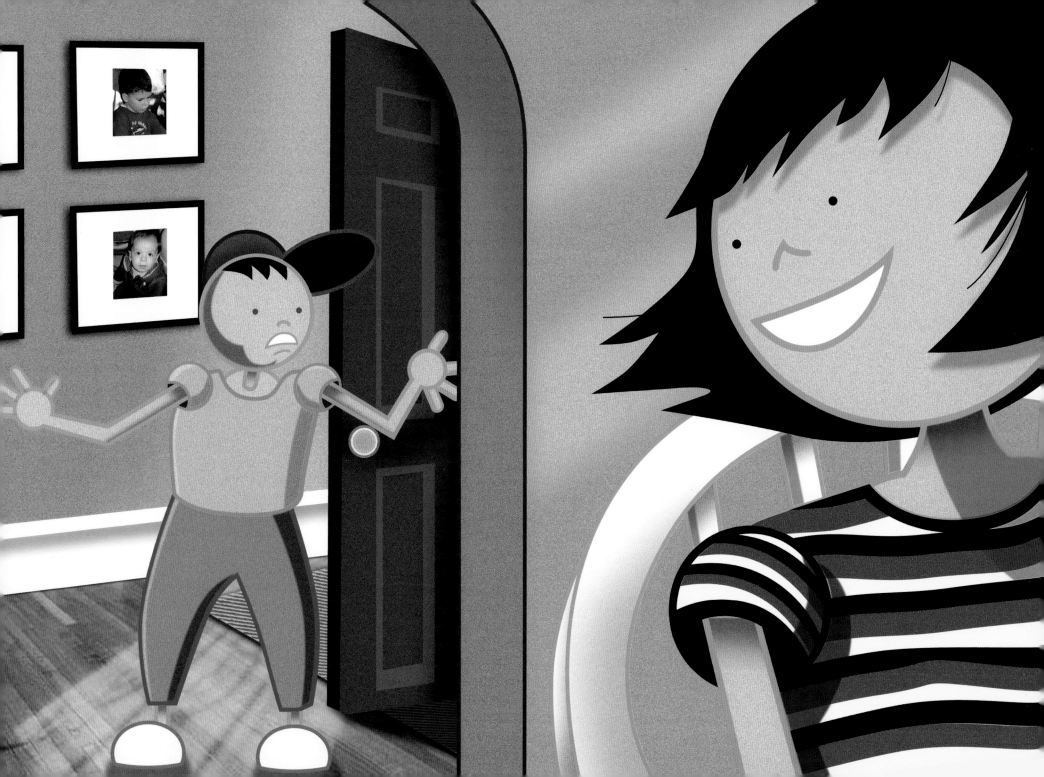

So off Sam went with a twinkle in his eye,

To enjoy a full day under the big blue sky.

On the way to the playground,

In a big round puddle,

Sam saw something — a long white string.

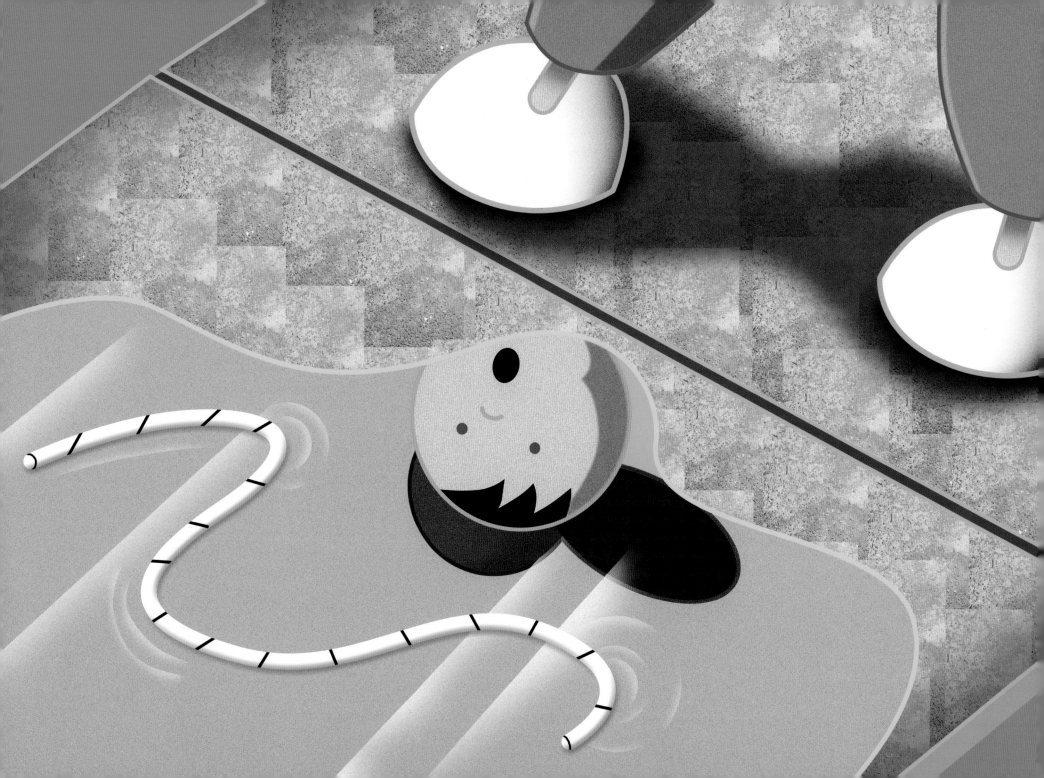

A string? Thought Sam. Did it fall from the sky?
Is this what Mommy meant? What the rain left behind?

But what good is a string? What fun can it bring?
It's not a ball for bouncing. Or a bike for riding.
It's just a silly string, this wet old thing.

Or was it?

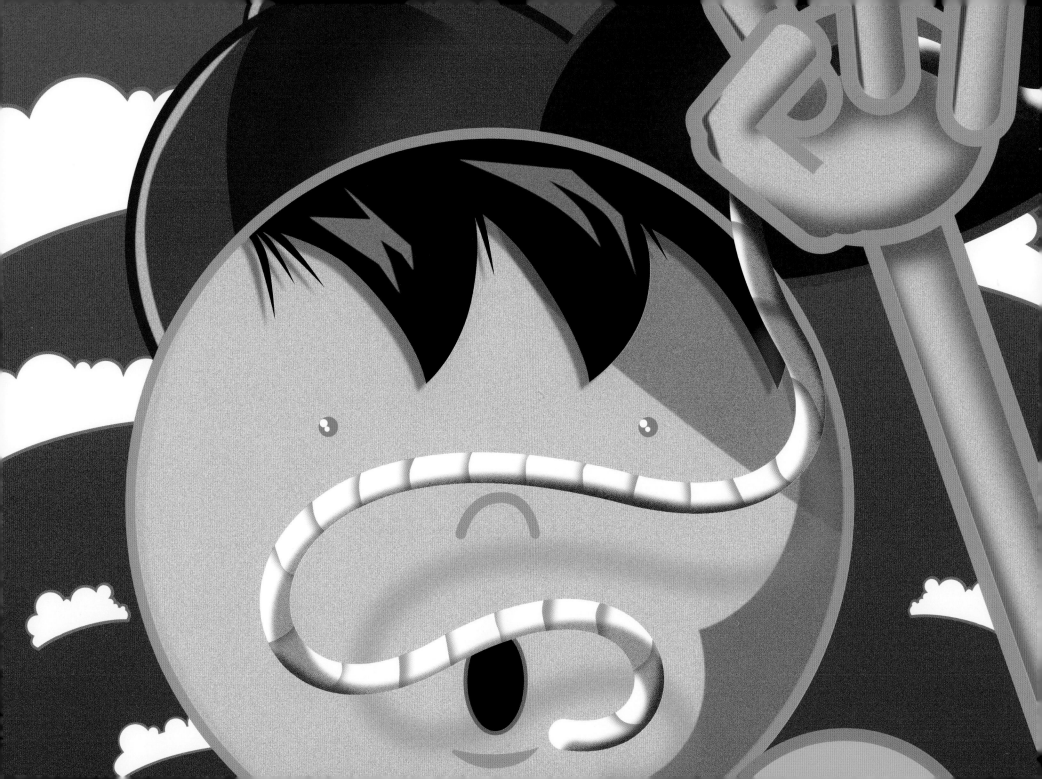

Sam thought and he thought.
He let his mind go free.
This string must do something,
But what could it be?

I know. Thought Sam. I'll use this string.
I'll stretch it long and make a big tree swing!

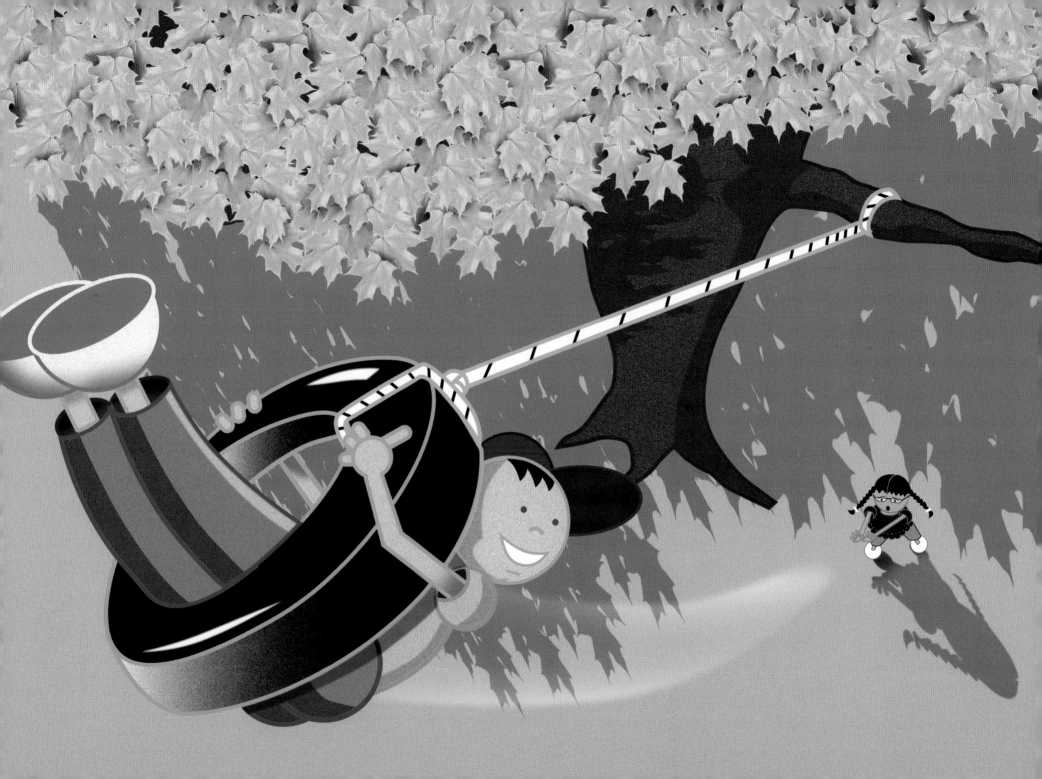

I know. Thought Sam. I'll use this string. I'll loop it through a pail for frog fishing.

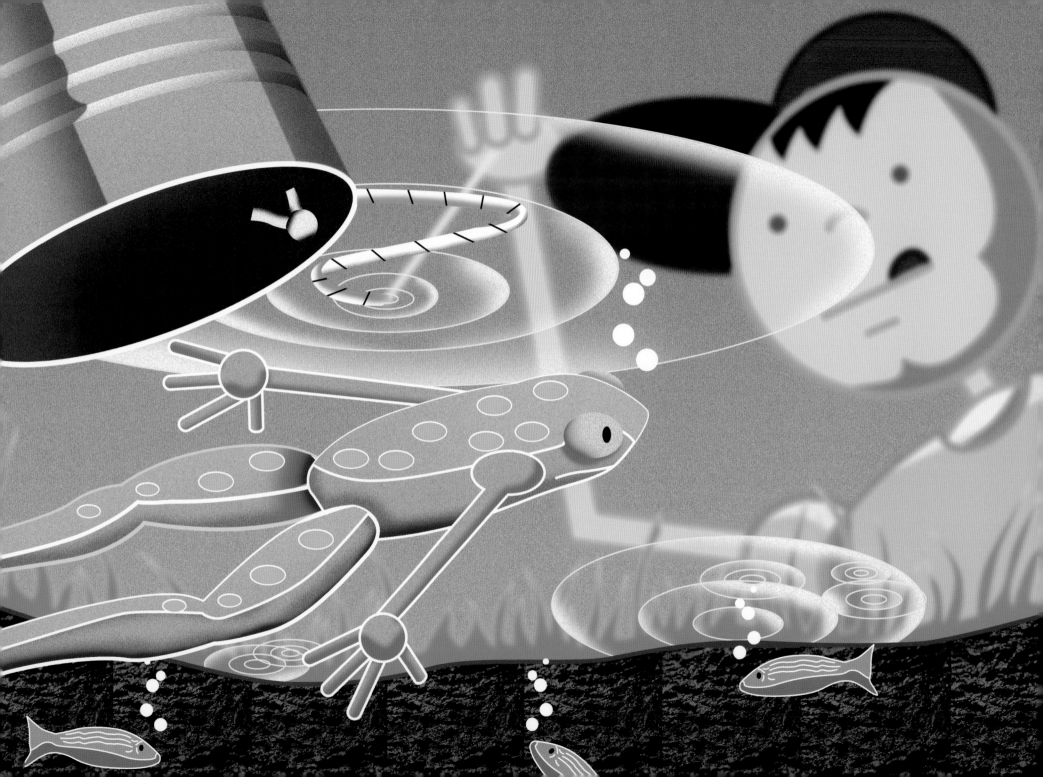

I know. Thought Sam. I'll use this string.
I'll escape the dinosaur by rock climbing.

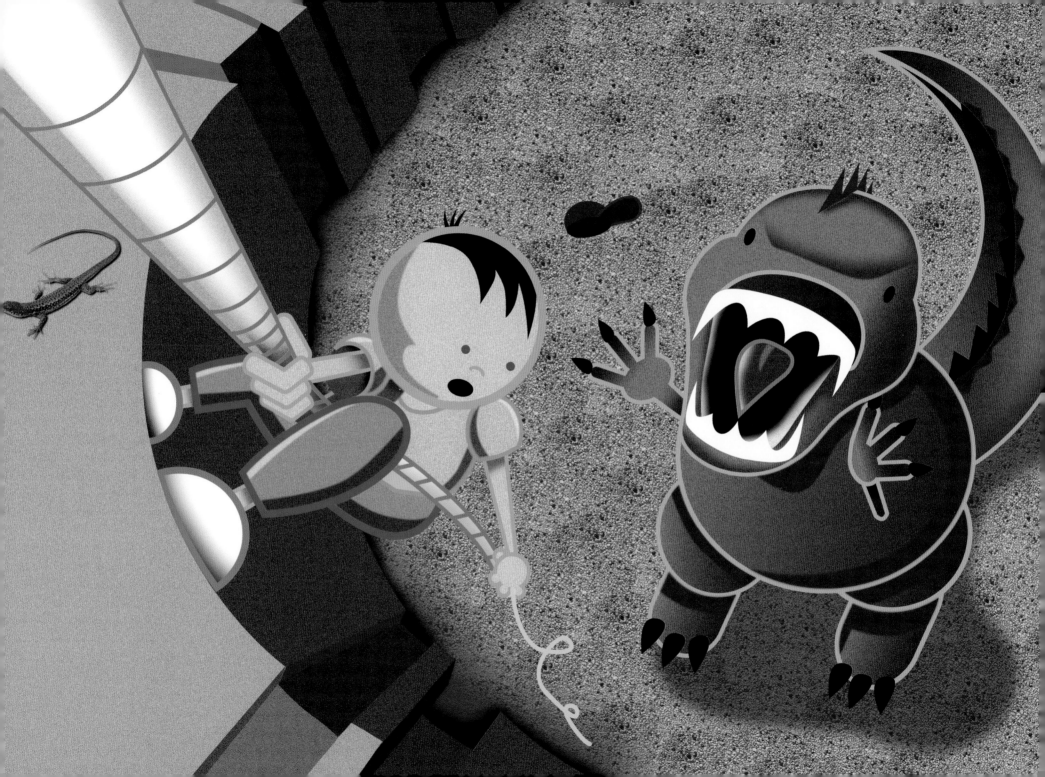

I know. Thought Sam. I'll use this string.
I'll invite my friends for jump roping.

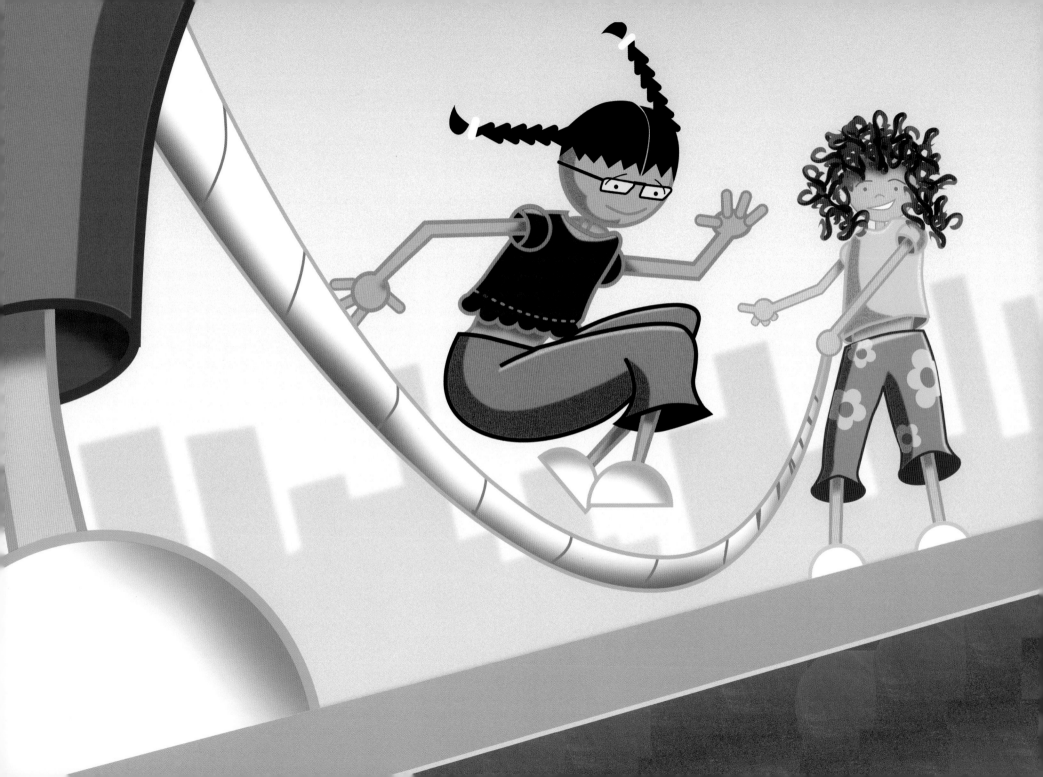

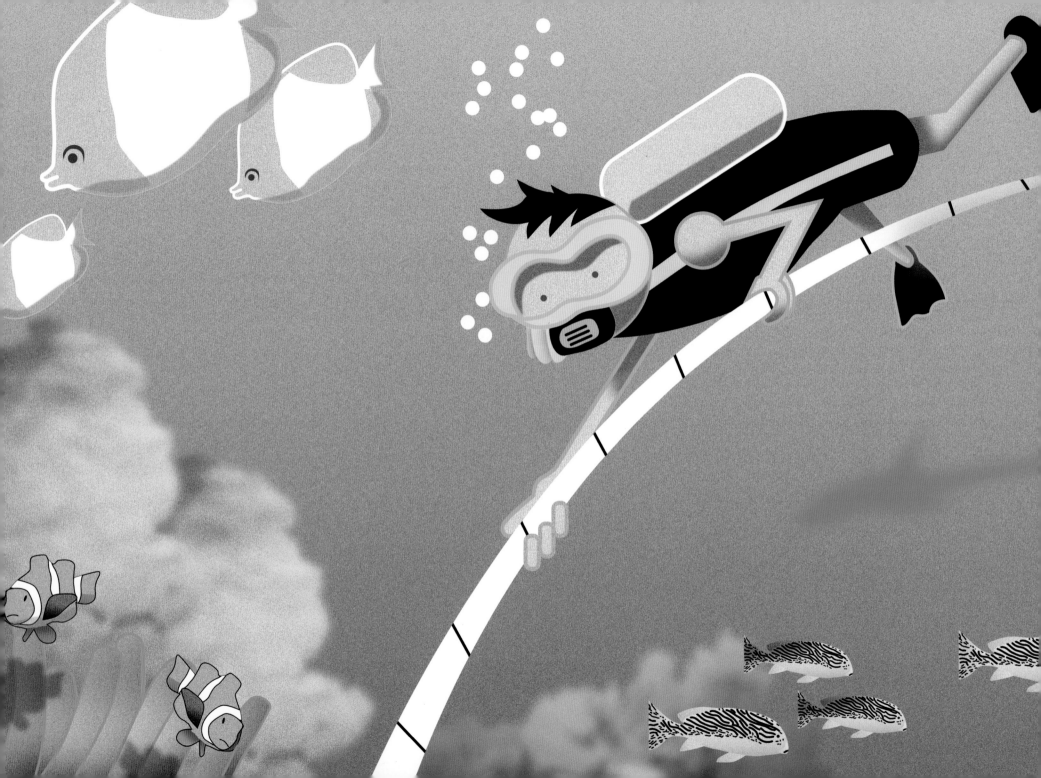

I know. Thought Sam. I'll use this string.
I'll see pretty fish by scuba diving.

I know. Thought Sam. I'll use this string.

I'll take it to the jungle and do some exploring.

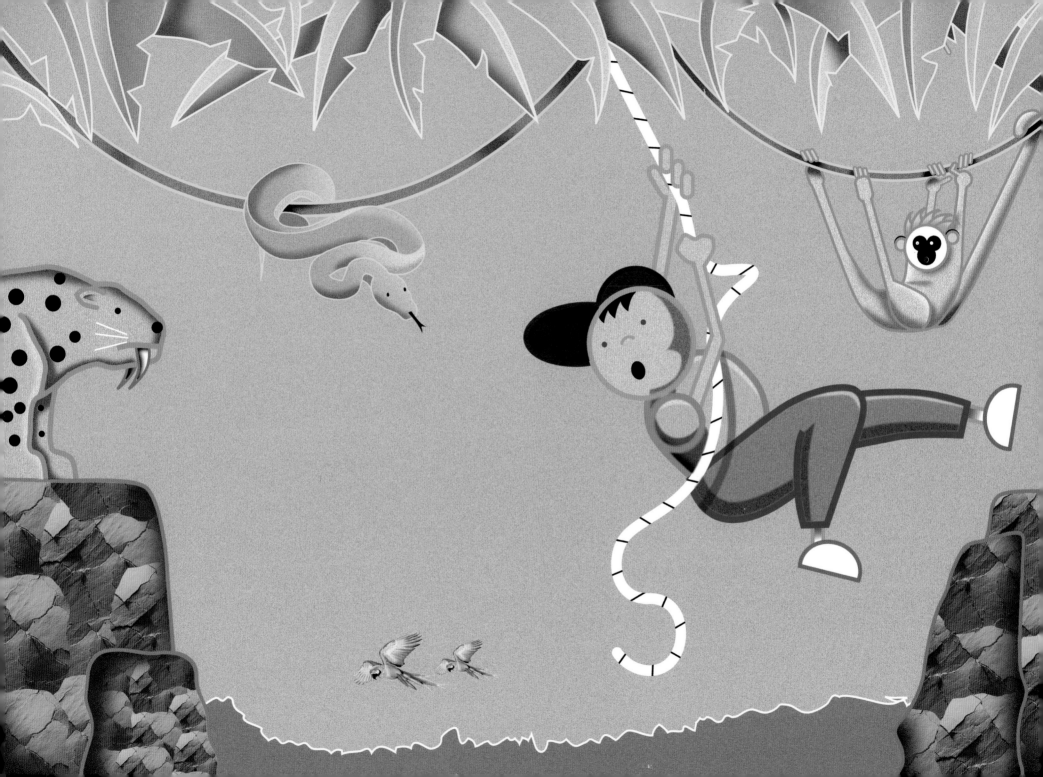

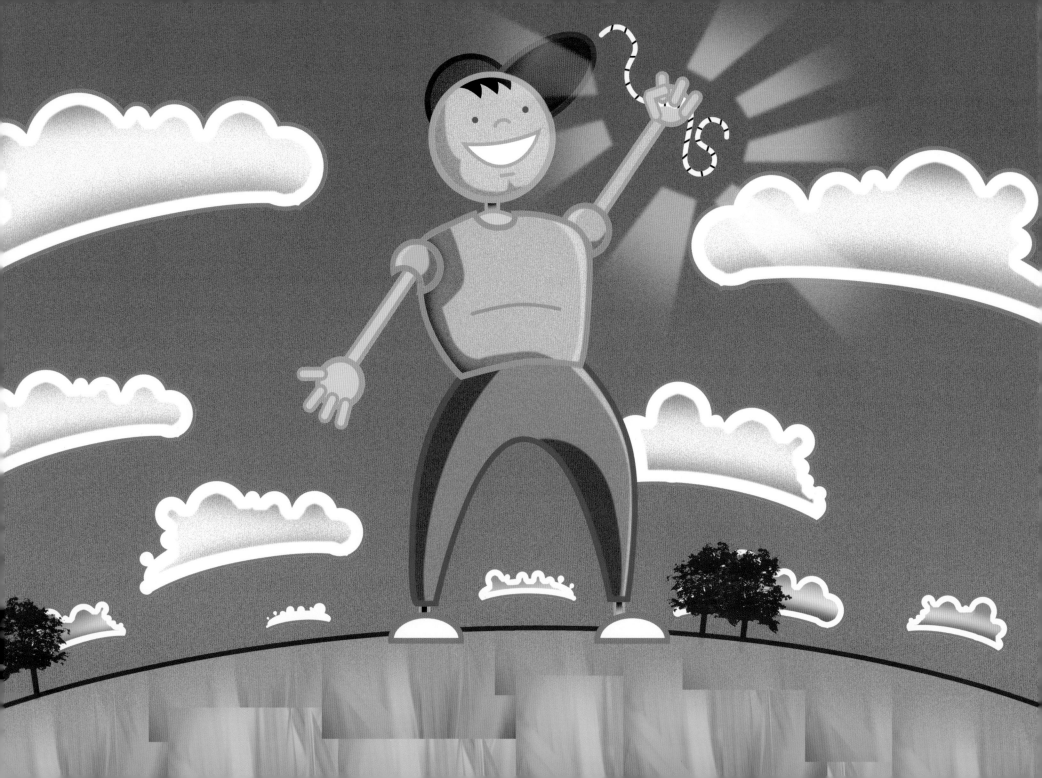

I know. Thought Sam. I'll use this string...
Sam worked all day and into the evening
To create something special out of the silly old string.

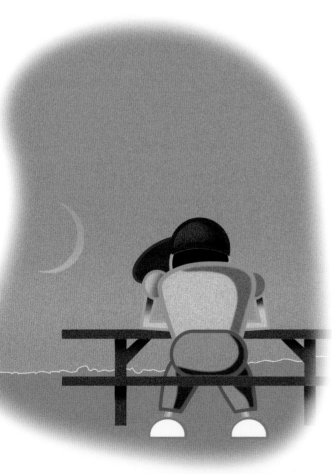

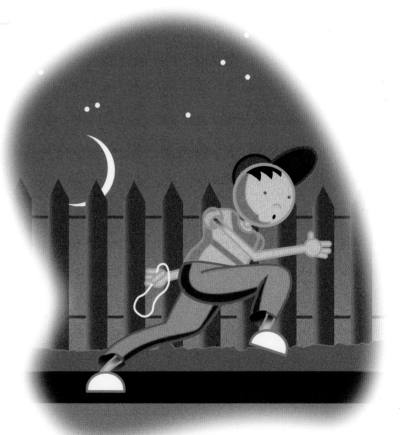

And of all the things he dreamed it could be,

The best thing of all was a gift for me.

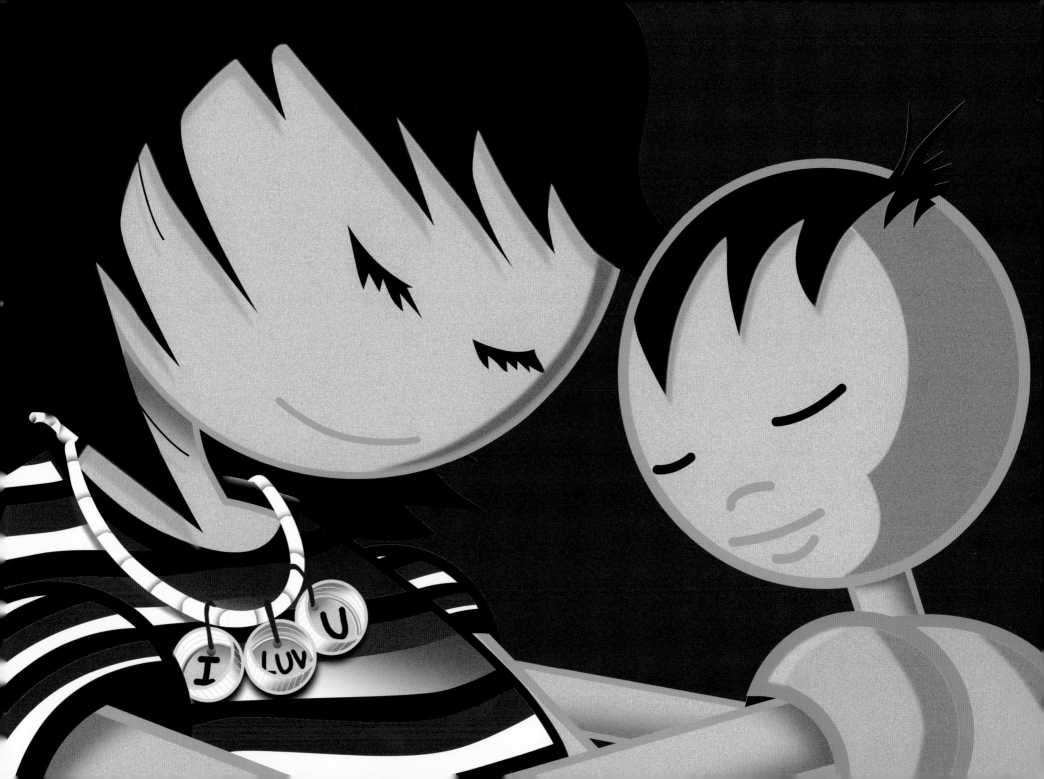

Julie Goulis *Author*

Julie discovered early on that her imagination could keep her entertained for hours. When she and her sisters weren't playing keep away from the imaginary crocodiles at the bottom of the stairs, she was out running around with her Holly Hobby doll. She also loved to read, with *Hansel and Gretel* as her favorite book. She now uses her imagination as an advertising copywriter and dreaming up new book ideas. Julie still has her Holly Hobby doll, but she has a new favorite children's book.

John Ferguson *Illustrator*

His bunk bed was a time machine that took him on adventures around the universe, which gave him ideas for the comics he drew. In between his inter-galactic adventures, John loved reading Curious George books and playing with his *Star Wars* toys. Years later, his time machine landed him in the advertising business, where he's a talented art director and illustrator. If his wife would let him, he'd still wear his Jedi costume out to trick or treat.

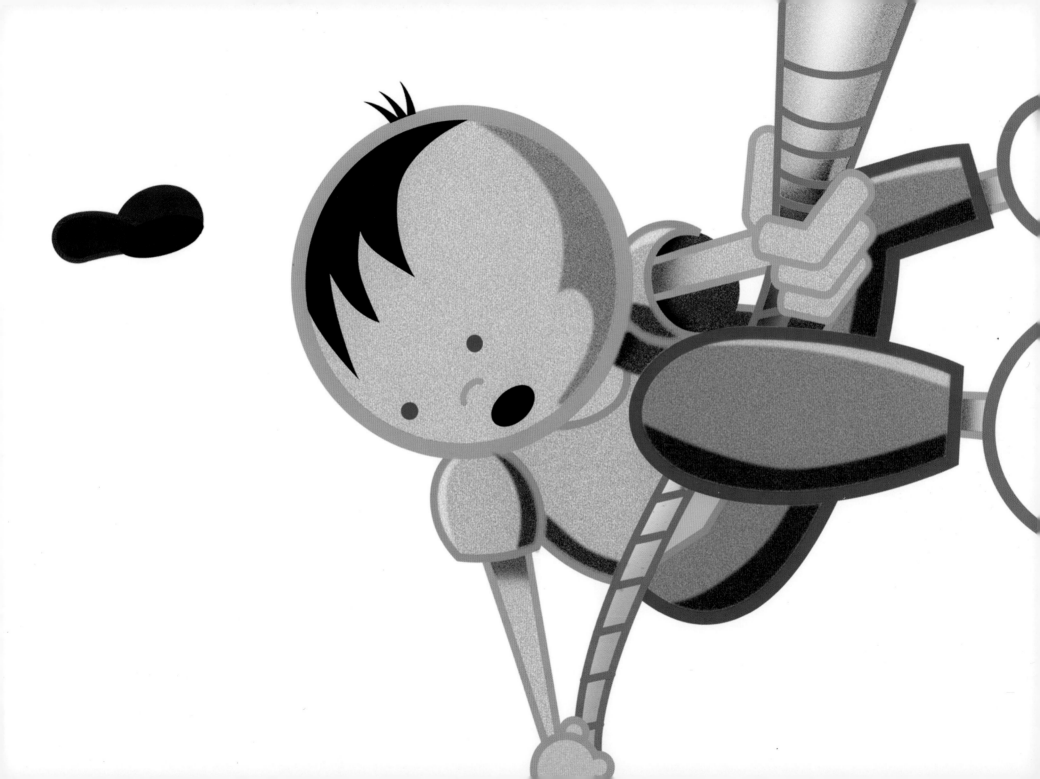